The Peaceful Pages Motley Coloring Book

Emerlye Arts® Sample
Variety Edition

Illustrations by Vermont Artist
Cynthia Emerlye

Copyright © 2024 by RE Emerlye

All rights reserved globally.

No part of this publication may be reproduced, distributed, or transmitted in any form or by any means, including photocopying, recording, or other electronic or mechanical methods, without the prior written permission of the publisher, except as permitted by U. S. copyright law.

Illustrations by Cynthia Emerlye

ISBN: 978-1-7345438-1-0

Published By Emerlye Arts LLC
Middlebury, Vermont

www.EmerlyeArts.com

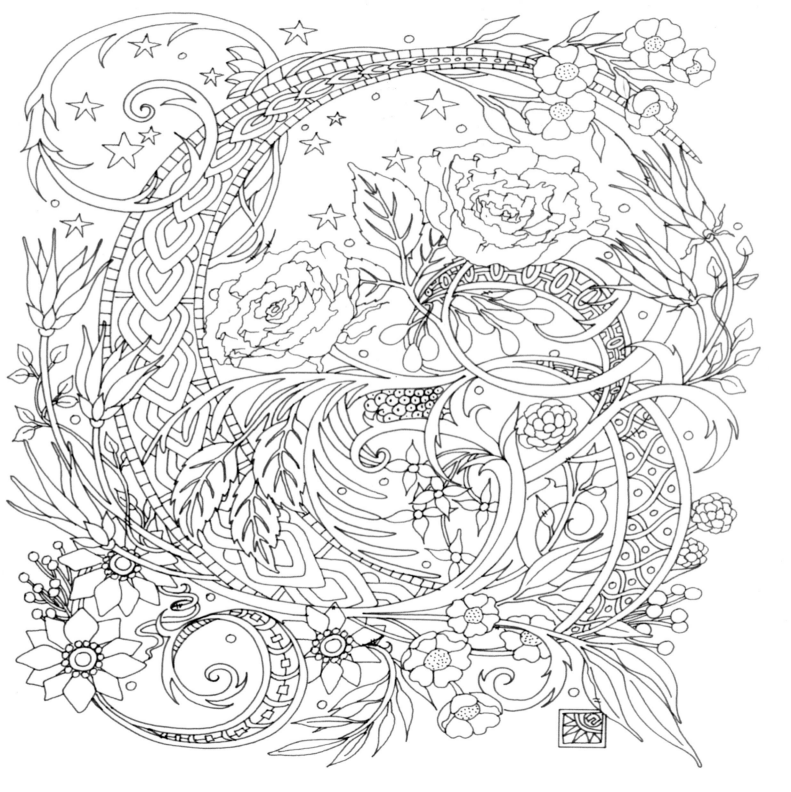

Emerlye Arts®
Peaceful Pages Collection Image
The Motley Coloring Book

140110
Stary Swirls

Dreamwalk Hint – Spiritual Translation

Flower – Faith, Hope, Love
Star – Divine Guidance
Spiral – Transformation, Evolution

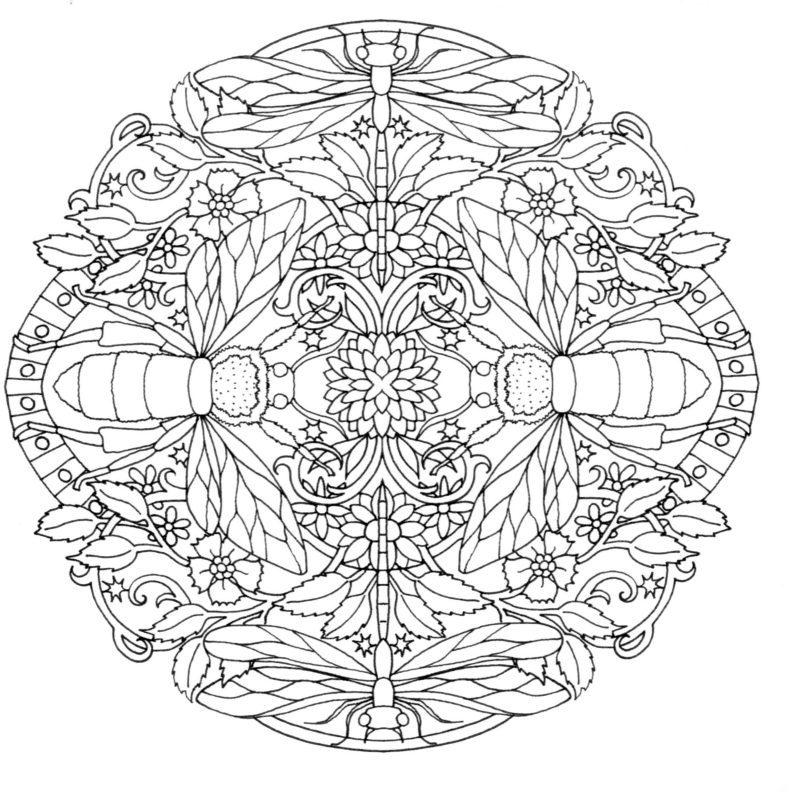

Emerlye Arts®
Peaceful Pages Collection Image
The Motley Coloring Book

130429
Insect Mandala

Dreamwalk Hint – Spiritual Translation

Dragonfly – The wisdom of adapting to change
Bee – Mysteries of the natural world
Vine – Strive against all odds
Flower – Faith, Hope, Love
Star – Divine Guidance

Emerlye Arts®
Peaceful Pages Collection Image
The Motley Coloring Book

140328
Polka Dot Ribbon

Dreamwalk Hint – Spiritual Translation

Polka Dots – Playfulness
Flower – Faith, Hope, Love
Fruit – Abundance, Fertility, Harv

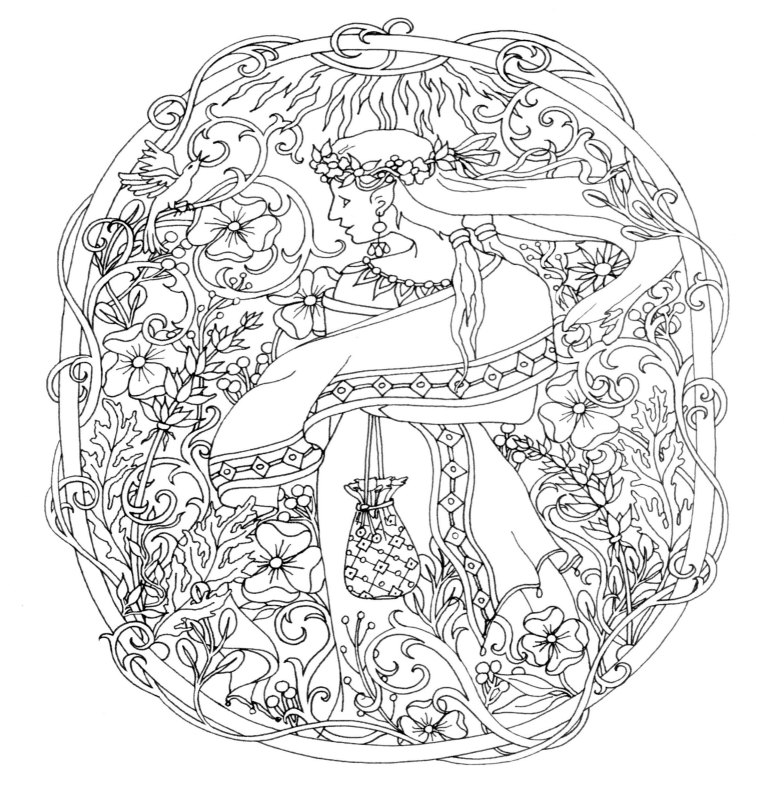

Emerlye Arts®
Peaceful Pages Collection Image
The Motley Coloring Book

131217
Elf Garden

Dreamwalk Hint – Spiritual Translation

Flower – Faith, Hope, Love
Sun – Hope, Renewal, Divinity
Garden – Mother Earth's Abundance
Bird – Freedom, Transcendence, Expansiveness, Keen Vision
Garland – Reputation, Happiness, Devotion, Respect, Peace
Elf – Magical, Ambivalent toward regular people,
The ability to help or hinder others

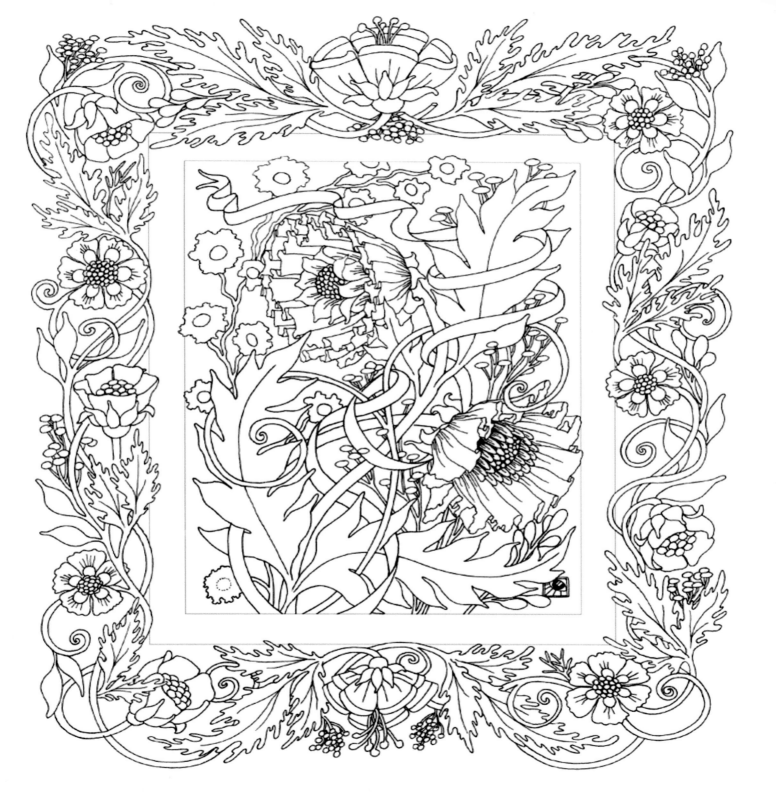

Emerlye Arts®
Peaceful Pages Collection Image
The Motley Coloring Book

070330
Flower Frame Line

Dreamwalk Hint – Spiritual Translation

Frame – Something significant needing to be focused on
Flower – Faith, Hope, Love
Ribbon – Solidarity, Joined in faith

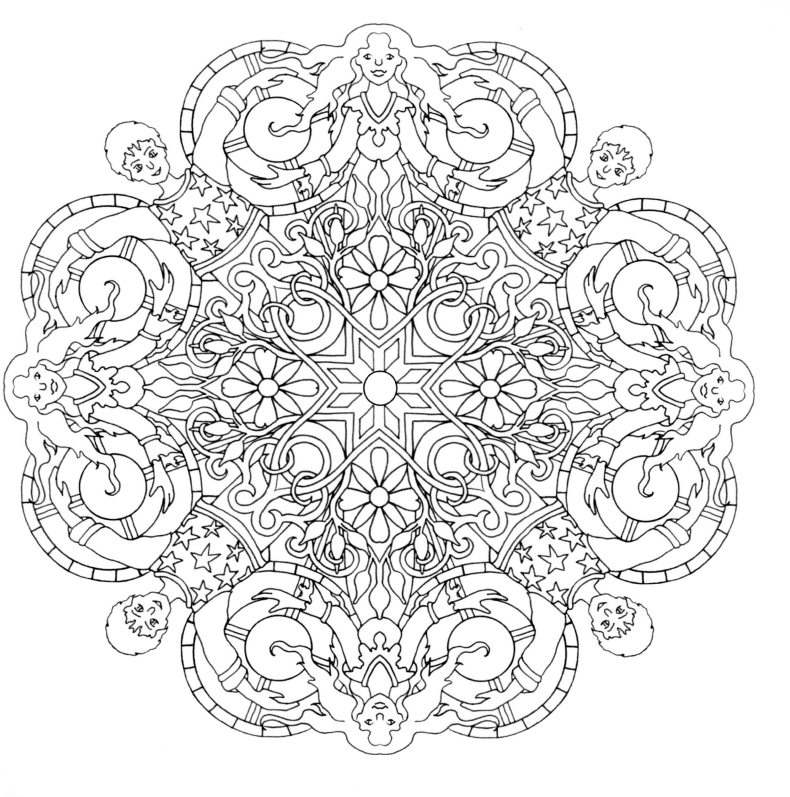

EMERLYE ARTS®
PEACEFUL PAGES COLLECTION IMAGE
THE MOTLEY COLORING BOOK

121227
YIN YANG MANDALA

DREAMWALK HINT – SPIRITUAL TRANSLATION

YIN YANG – A BALANCE OF TWO OPPOSITES
WITH A PORTION OF THE OPPOSITE ELEMENT IN EACH SECTION
STAR – DIVINE GUIDANCE
FLOWER – FAITH, HOPE, LOVE

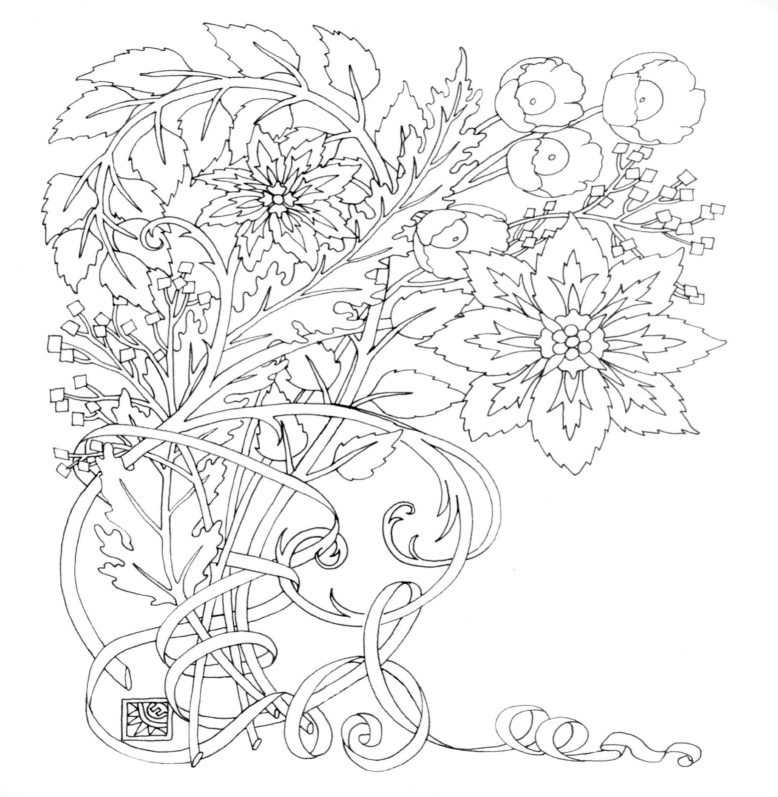

EMERLYE ARTS®
PEACEFUL PAGES COLLECTION IMAGE
THE MOTLEY COLORING BOOK

130702
BOUQUET SENTIMENT

DREAMWALK HINT – SPIRITUAL TRANSLATION

FLOWER – FAITH, HOPE, LOVE
BOUQUET – LIFE JOURNEY, FROM BUD TO BLOOM, REMINDING OF THE BEAUTY AND THE IMPERMANENCE INHERENT IN ALL THINGS
RIBBON – SOLIDARITY, JOINED IN FAITH
SQUARE – STURDINESS, STRENGTH, COMPLETENESS

Emerlye Arts®
Peaceful Pages Collection Image
The Motley Coloring Book

130819
Jacobean Hemp

Dreamwalk Hint – Spiritual Translation

Flower – Faith, Hope, Love
Berries – Sweetness in life, Modesty
Hemp – Source of happiness, Joy giver, Liberator, Useful fibrous plants
Jacobean – Fostering new beliefs while still embracing old religious ideals

Emerlye Arts®
Peaceful Pages Collection Image
The Motley Coloring Book

130821
Medieval Gown

Dreamwalk Hint — Spiritual Translation

Distinguished Gown — Democracy of scholarship
Belt — Spiritual power, Protection, Secure all internal things
Flower — Faith, Hope, Love
Vine — Divine and human nature united in the same spirit

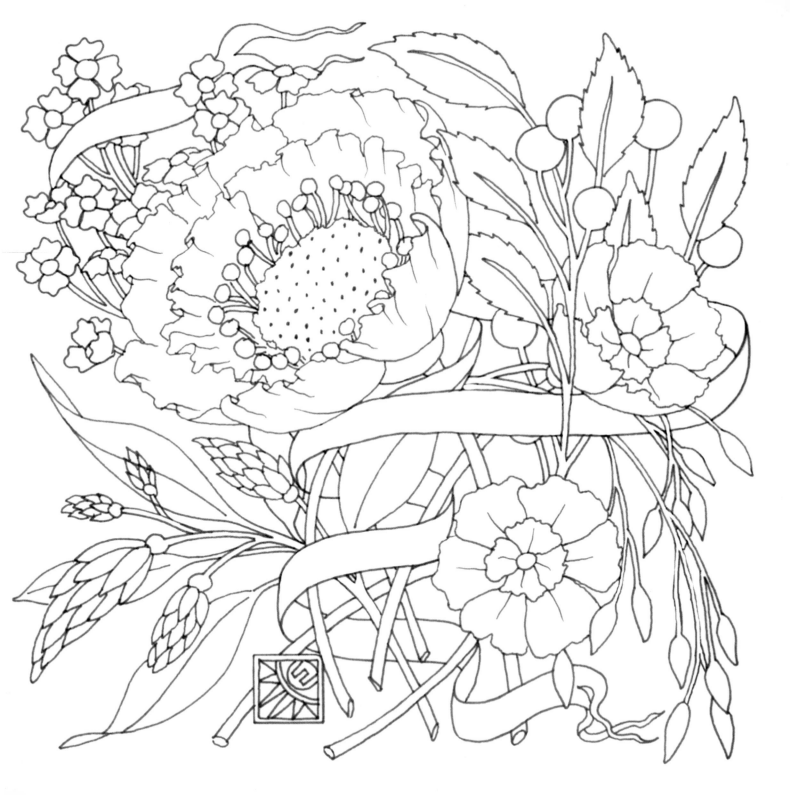

Emerlye Arts®
Peaceful Pages Collection Image
The Motley Coloring Book

130927
Square Scratch

Dreamwalk Hint – Spiritual Translation

Hops – Promote healing, The cycle of life, Perpetual development
Flower – Faith, Hope, Love
Berries – Sweetness in life, Modesty
Wheat – Sustenance, Abundance
Ribbon – Solidarity, Joined in faith

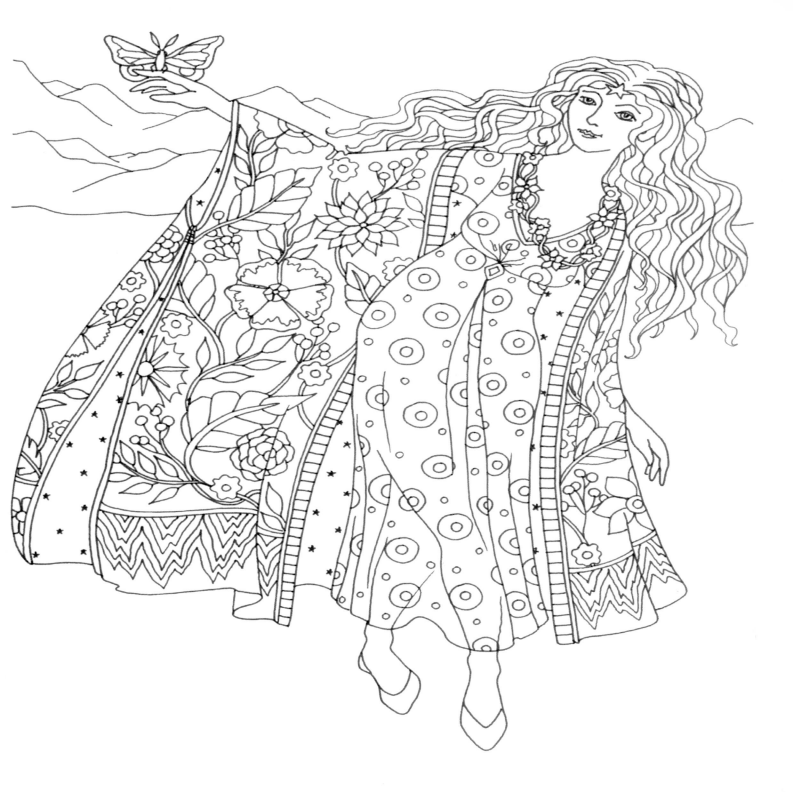

Emerlye Arts®
Peaceful Pages Collection Image
The Motley Coloring Book

150707
Star Woman

Dreamwalk Hint – Spiritual Translation

Mountains – Consistency, Permanence, Motionless
Star – Divine Guidance
Berries – Sweetness in life, Modesty
Butterfly – Transformation, time to play, Lightness
Flower – Faith, Hope, Love
Distinguished Gown – Democracy of scholarship
Necklace – Conveying faith, Bond, Devotion

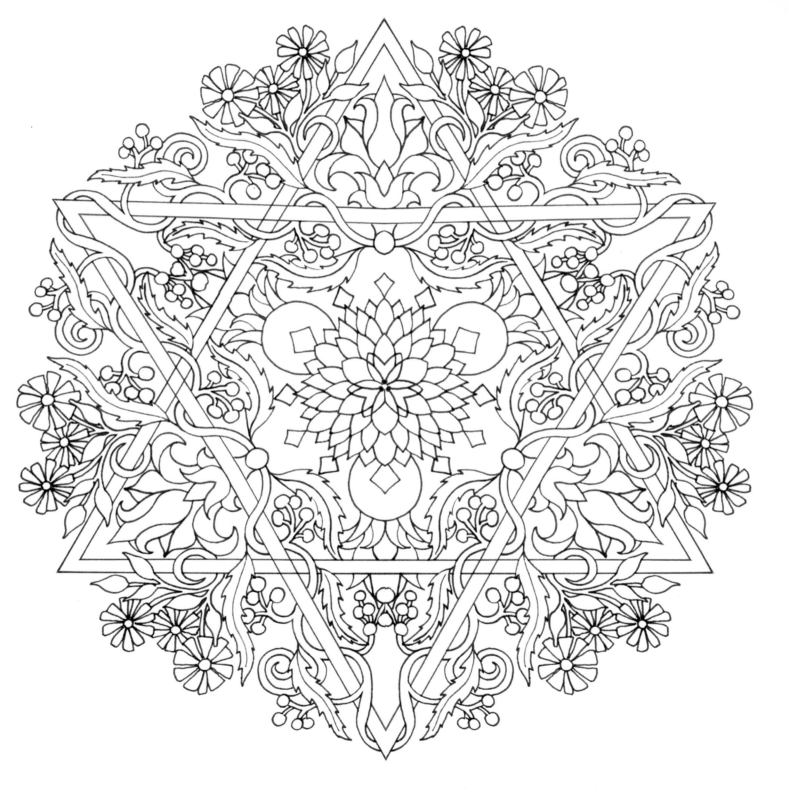

Emerlye Arts®
Peaceful Pages Collection Image
The Motley Coloring Book

140225
Marigold Star Mandala

Dreamwalk Hint – Spiritual Translation

Star – Divine Guidance
Flower – Faith, Hope, Love
Berries – Sweetness in life, Modesty
Marigold – Good luck, Warmth, Auspiciousness
Vine – Divine and human nature united in the same spirit

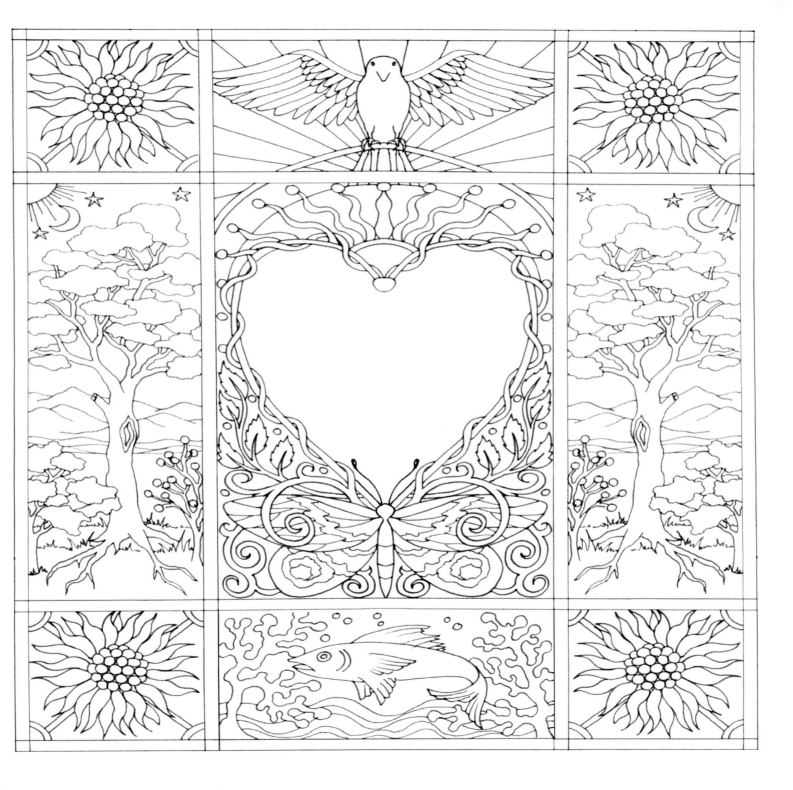

Emerlye Arts®
Peaceful Pages Collection Image
The Motley Coloring Book

131101
Love At The Center Heart

Dreamwalk Hint – Spiritual Translation

Moon – Growth, Manifestation
Sun – Hope, Renewal, Divinity
Cycles of life – Stages of development
Flower – Faith, Hope, Love
Bird – Freedom, Transcendence, Expansiveness, Keen vision
Butterfly – Transformation, time to play, Lightness
Fish – Peace, Stability, Balance, Tranquility
Trees – The beauty of life itself
Star – Divine Guidance

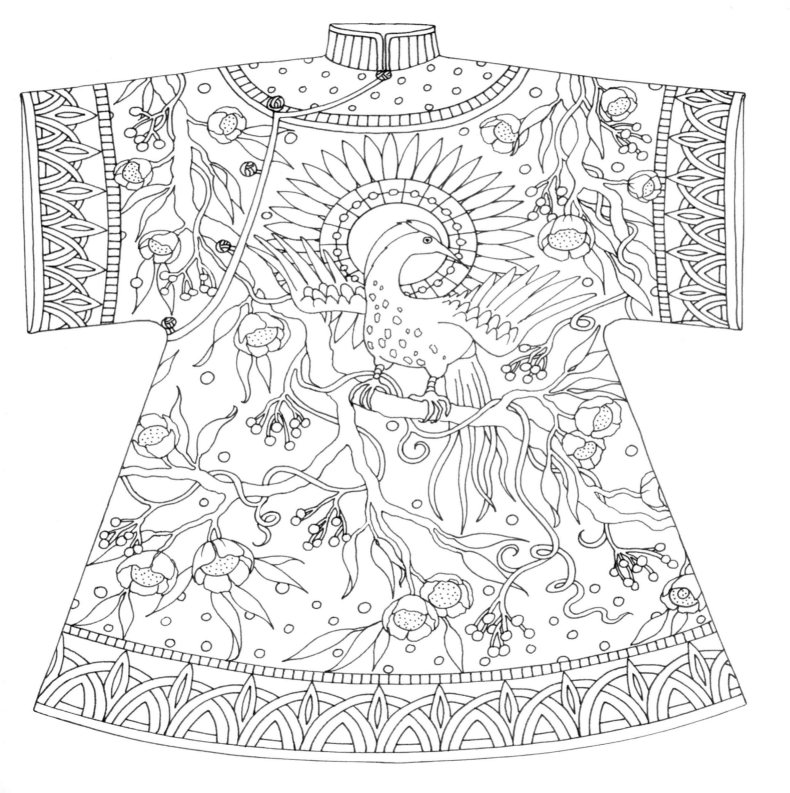

Emerlye Arts®
Peaceful Pages Collection Image
The Motley Coloring Book

140114
Chinese Bird Coat

Dreamwalk Hint – Spiritual Translation

Distinguished Gown – Democracy of scholarship
Bird – Freedom, Transcendence, Expansiveness, Keen vision
Berries – Sweetness in life, Modesty
Poppies – Eternal Sleep, Rest, Realm of the afterlife

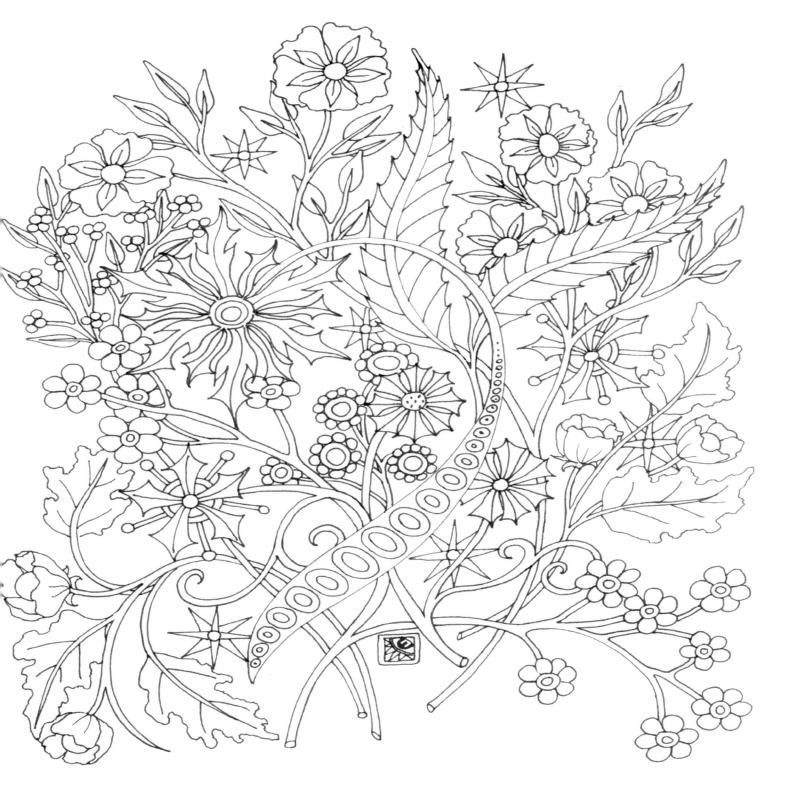

Emerlye Arts®
Peaceful Pages Collection Image
The Motley Coloring Book

140213
Bunch of Flowers

Dreamwalk Hint – Spiritual Translation

Garden – Mother Earth's Abundance
Flower – Faith, Hope, Love
Star – Divine Guidance

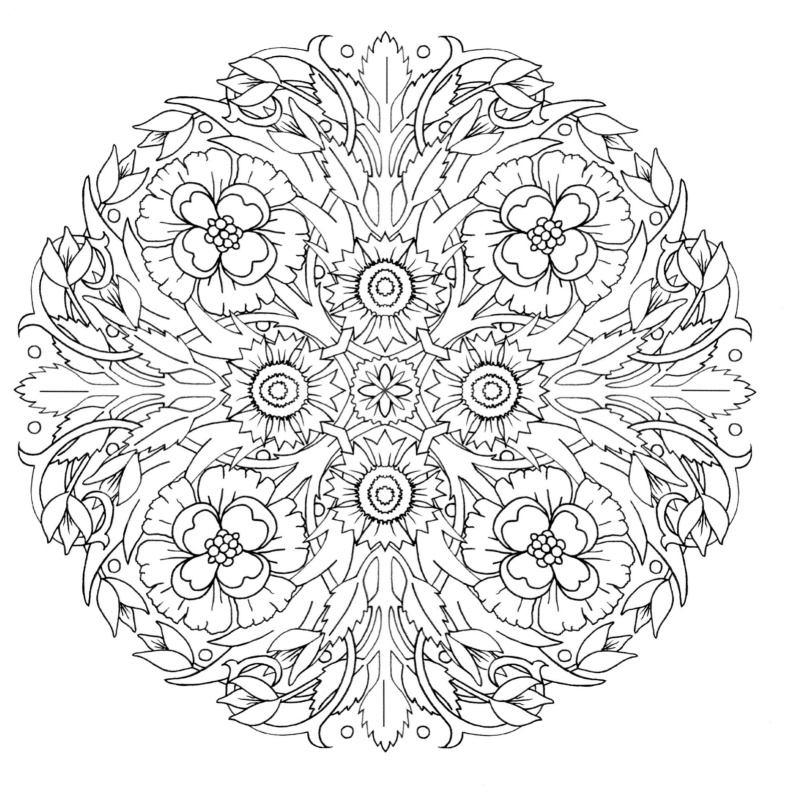

Emerlye Arts®
Peaceful Pages Collection Image
The Motley Coloring Book

130506
Ragged Leaf Mandala

Dreamwalk Hint – Spiritual Translation

Ragged – torn, worn from use
Garden – Mother Earth's Abundance
Vine – Divine and human nature united in the same spirit
Flower – Faith, Hope, Love

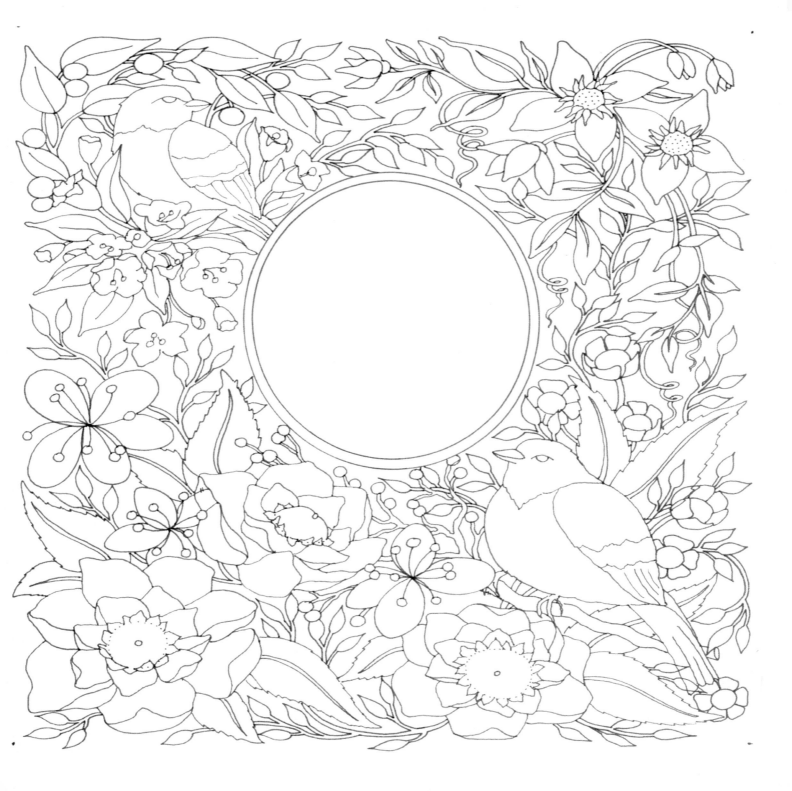

Emerlye Arts®
Peaceful Pages Collection Image
The Motley Coloring Book

160101
Bird & Flower Oval Boarder

Dreamwalk Hint – Spiritual Translation

Bird – Freedom, Expansiveness, Keen Vision
Garden – Mother Earth's Abundance
Flower – Faith, Hope, Love
Vine – Divine and human nature united in the same spirit

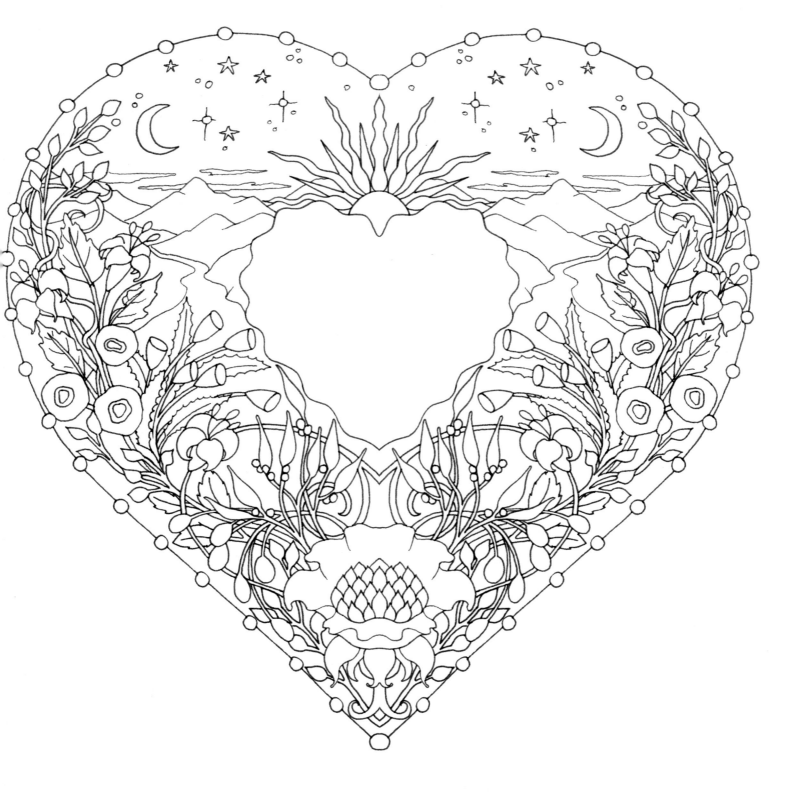

Emerlye Arts®
Peaceful Pages Collection Image
The Motley Coloring Book

151224
Nature Heart

Dreamwalk Hint – Spiritual Translation

Moon – Growth, Manifestation
Vine – Divine and human nature united in the same spirit
Garden – Mother Earth's Abundance
Flower – Faith, Hope, Love

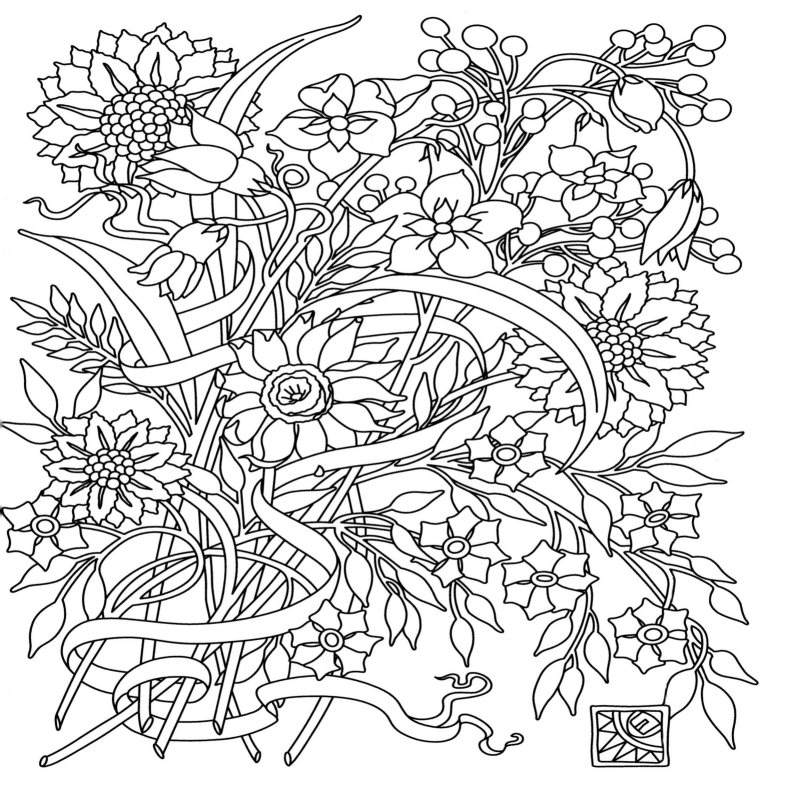

Emerlye Arts®
Peaceful Pages Collection Image
The Motley Coloring Book

130618
Mumsy

Dreamwalk Hint – Spiritual Translation

Flower – Faith, Hope, Love
Garden – Mother Earth's Abundance
Bouquet – Life journey, From bud to bloom, Reminding of the beauty and the impermanence inherent in all things
Ribbon – Solidarity, Joined in faith

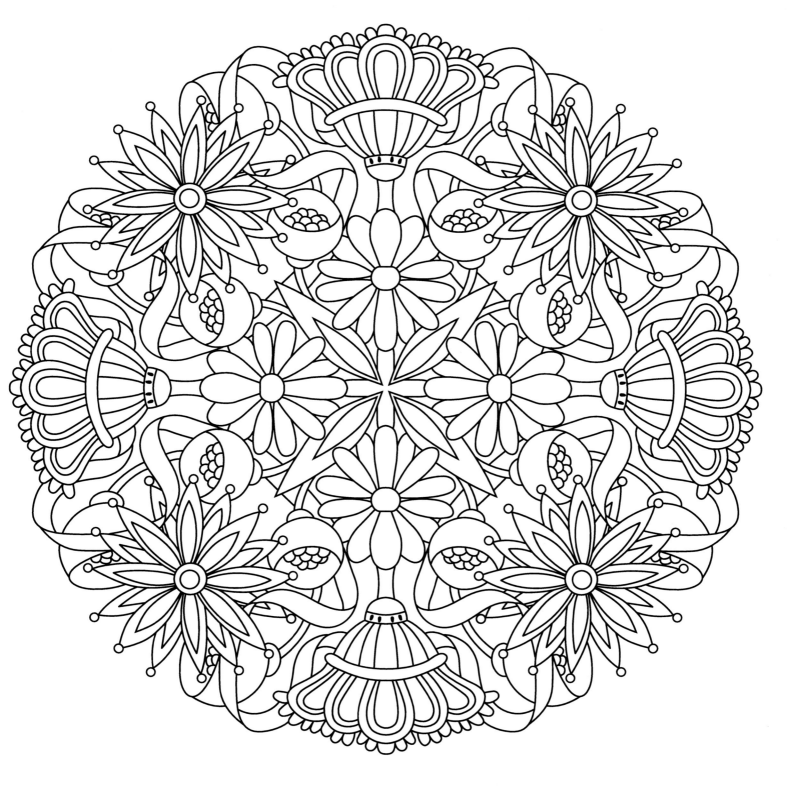

Emerlye Arts®
Peaceful Pages Collection Image
The Motley Coloring Book

121223
Daisy Mandala

Dreamwalk Hint – Spiritual Translation

Daisy – New beginnings
Flower – Faith, Hope, Love

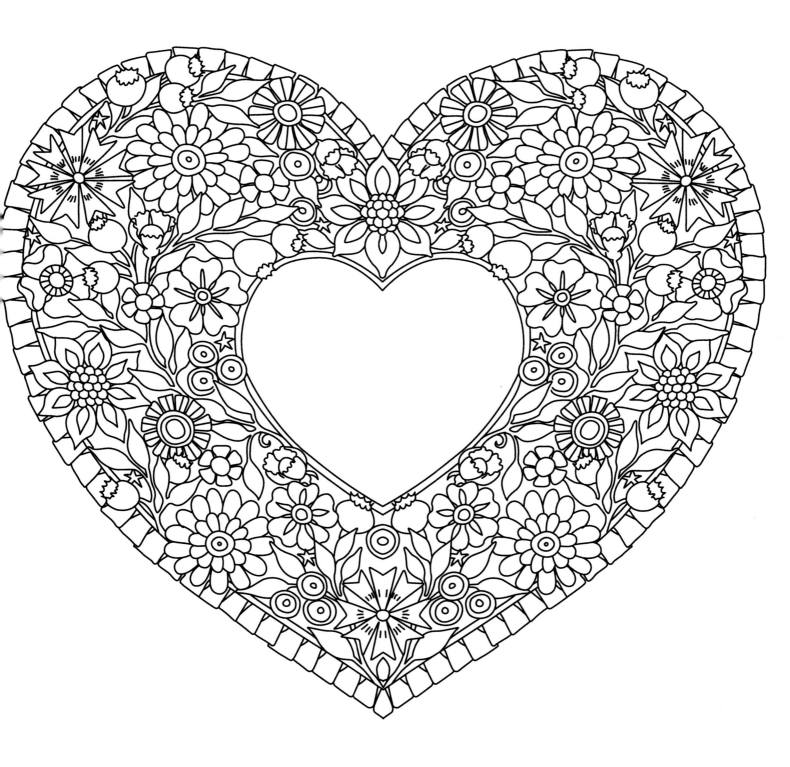

Emerlye Arts®
Peaceful Pages Collection Image
The Motley Coloring Book

131027

Abundant Flower Heart

Dreamwalk Hint – Spiritual Translation

Blueberries – Inner wisdom, Intuition, Tranquility
Abundance – Elevating the idea of plenty
Flower – Faith, Hope, Love
Star – Divine guidance

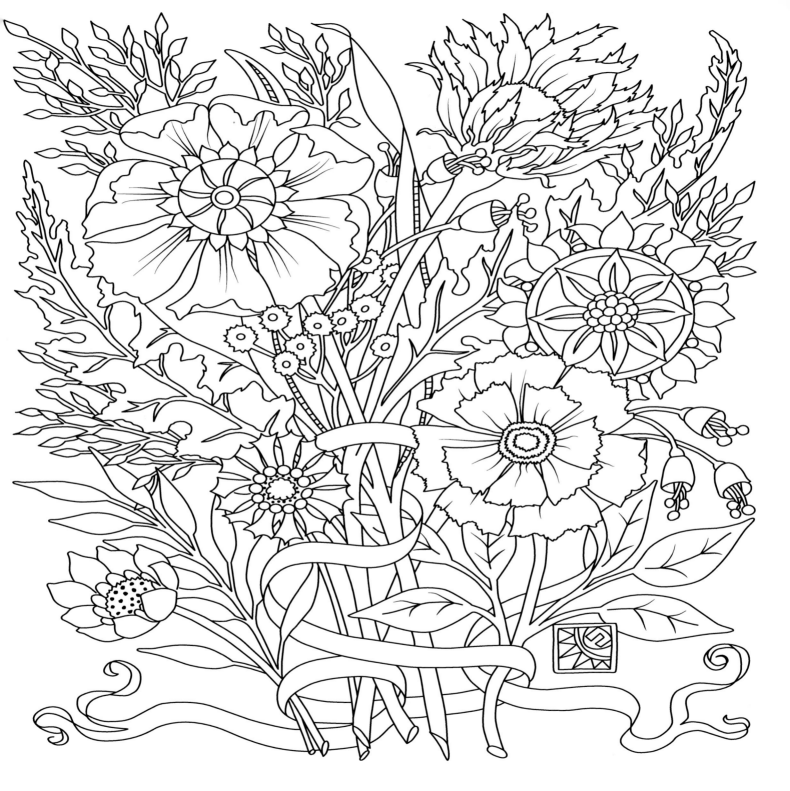

Emerlye Arts®
Peaceful Pages Collection Image
The Motley Coloring Book

130715
Variety

Dreamwalk Hint – Spiritual Translation

Bouquet – Life journey, From bud to bloom, Reminding of the beauty and the impermanence inherent in all things
Flower – Faith, Hope, Love
Ribbon – Solidarity, Joined in faith

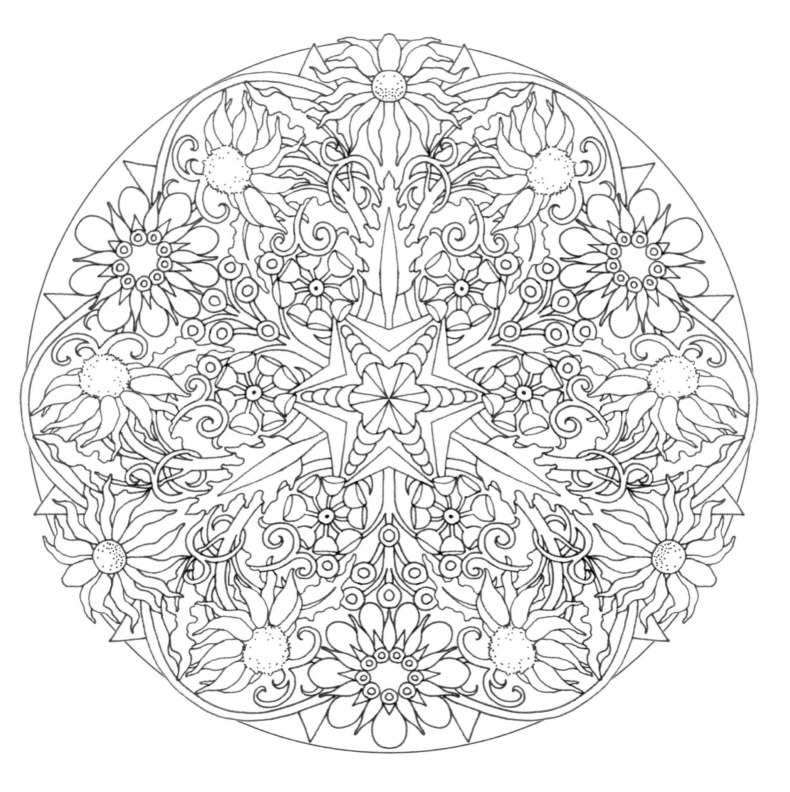

Emerlye Arts®
Peaceful Pages Collection Image
The Motley Coloring Book

140828
Rudbeckia Mandala

Dreamwalk Hint – Spiritual Translation

Rudbeckia – Motivation, Resilience, Encouragement
Garden – Mother Earth's Abundance
Flower – Faith, Hope, Love

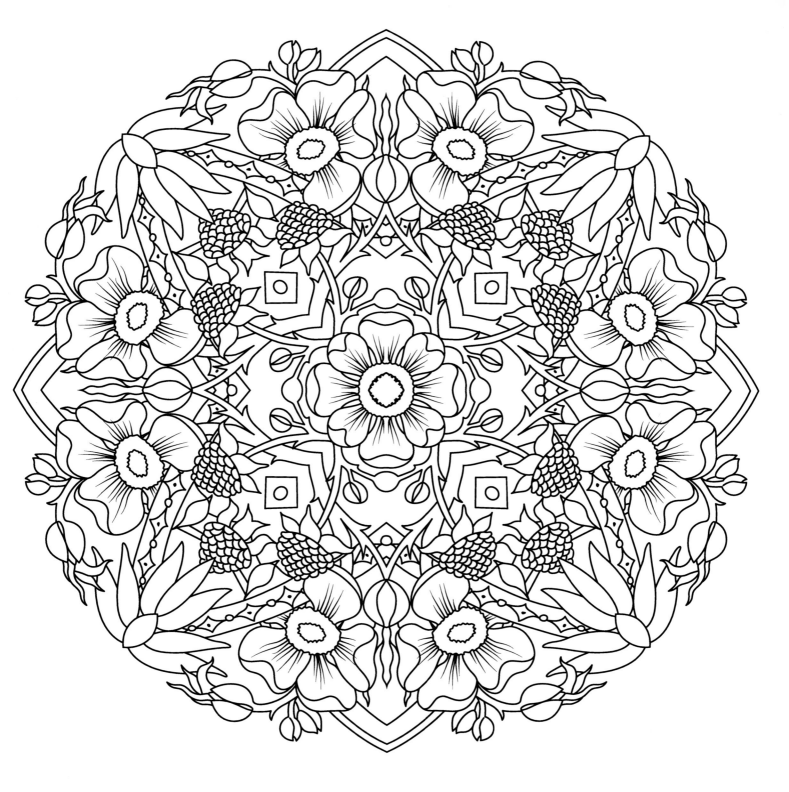

Emerlye Arts®
Peaceful Pages Collection Image
The Motley Coloring Book

130409
Raspberry Mandala

Dreamwalk Hint – Spiritual Translation

Raspberry – Spiritual symbolism of blood fueling the body with life and kindness

Sprouting seeds – Spiritual journey of life, Spiritual development

Flower – Faith, Hope, Love

The Artist & The Author

Cynthia Emerlye lived on a tranquil farm in Pomfret, Vermont, where she painted and created numerous works of art. Formally and informally trained, her style is detailed, elegant, symbolic, and distinctly feminine. Influenced by the richly illuminated manuscripts of the Renaissance and the intricate designs of Arts & Crafts period artists like William Morris, her work has been adapted for various decorative commercial applications.

In addition to her artwork, CB Emerlye spent many years as a transformational life coach and counselor. She drew upon her illustrations and creative ideals to inspire others to seek beauty in life using it to uplift their spirits. In her later years, she specialized in helping individuals transform their lives through a deeper understanding of themselves, utilizing her dreamwalk method, dowsing, healing practices, and traditional goal-setting strategies.

The youngest daughter of the artist, RE Emerlye developed the coloring exercises in this book, aiming to combine her mother's interest in using Emerlye Arts illustrations as healing tools for mediation and reflection.

Made in United States
Orlando, FL
09 December 2024